YOGA
FOR
GIRLS

SEEMA SONDHI

wisdom
tree

To all my students

Cover Model : Tara Lowen
Photographs : Hemant Chawla

ISBN 81-8328-002-1

Published by

Wisdom Tree
C-209/1 Mayapuri, Phase-II
New Delhi-110 064.
Tel.: 28111720, 28114437

Published by *Shobit Arya* for Wisdom Tree; edited by *Manju Gupta*; designed by *Kamal P. Jammual*; typeset at Icon Printographics, New Delhi-18 and printed at Print Perfect, New Delhi-64

Preface

Energetic, vibrant, creative and intelligent go getters—that's what today's young girls are described as. Sadly the fast paced metropolitan lifestyle and cut throat competition is making them victims of stress, lack of self-confidence and depression.

Having two growing girls of my own, I realised that today's adolescent is under the widespread delusion that yoga is less interesting and less beneficial than its counterpart exercise. But yoga will help them attain eventually a strong union between the mind and body—and this is a sure short ingredient for success in today's fast-paced lifestyle.

A variety of *asana* enable young bodies to become flexible and supple. Nature is truly unfair to them, at an age where appearance matters more, they are not satisfied by what they see in the mirror. Yoga will definitely provide certain exercises for the young girls who are looking to lose weight. Regular practice of *pranayama* will teach them to slow down, relax and gather their thoughts. Meditation will increase concentration, memory and teach how to control thoughts and be positive throughout.

Never forget that in adolescence, girls are walking towards womanhood, the bodies are changing and they are experiencing

emotional and intellectual maturity. This change is frightening and confusing and they need to hold on to a system that will teach them to accept and love themselves. Through the regular practice of yoga and meditation they will gain self-confidence and have the capability to take on life's challenges with a clear mind and a healthy body.

Contents

1

Yoga for Teens

The onset of puberty coupled with subsequent transformation into a young adult brings about immense changes in the body's physiology. The growth and change in the internal organs give rise to hormonal imbalance, frequent mood swings and diet changes. As the girl's body grows many external and internal changes are felt and observed: the development of breasts, the start of menstrual cycle, and the sudden increase in weight often confuse and disturb young girls, especially the 'late developers'.

This is where yoga and its regular practice will maintain balance in the body and keep the mind strong and healthy. Yoga promotes unification of the body, mind and soul. As you practise this ancient art, you will start to live your life with full awareness and appreciation. You will start seeing yourself in a new light, feeling and trusting yourself with a sense of confidence and you will be able to face this period of change with a positive outlook. The regular practice will improve your fitness level and health, giving you confidence, poise and grace.

2

Yoga for You

Yoga is a single tradition that has grown numerous branches in the course of its long existence and this tree of yoga is still growing. Yoga encompasses many different styles and approaches but integral to all of them is the essence of the word *yoga*, meaning 'union'. During the practice of yoga the body is connected with the mind and breath with movement to bring in a state of total relaxation and harmony. There is increased physical well-being, improved posture, more strength and flexibility, and detoxification and toning of the internal organs. Muscles and skin toning are the side benefits of yoga.

Understanding a bit about the popular methods of yoga will help you choose the kind that's just right for you. The tree of yoga is *hatha* meaning 'force'. It symbolises the union of sun and the moon, and is a term used by *yogis* to describe the physical and breathing exercises that still the mind.

Although there are many styles of yoga, the difference is basically in the style of teaching, such as holding the postures, coordination of breath and movement of the body. It is interesting to know that all

the styles share a common lineage. The founders of the three major styles—Ashtanga, Iyengar and Viniyoga were all students of Swami T. Krishnamacharya. The other styles, Sivananda and Bihar school of yoga, were started by disciples of Swami Sivananda. No style is better than the other, as the emphasis and content are same; it is simply a matter of personal preference. But the key essence is the student-teacher relationship.

ASHTANGA VINYASA YOGA

Ashtanga yoga as taught by K. Pattabhi Jois is a dynamic practice with a series of breath-synchronised movements that continuously flow from one to the next. The use of specific breathing and application of body locks help to create heat, which in turn has a powerful detoxification effect. It is suitable for fairly active people who are willing to challenge themselves physically.

IYENGAR YOGA

Iyengar yoga as taught by B.K.S. Iyengar is a rigorous and thorough training of the body and mind. It lays more emphasis on correct alignment of the bone structure, with use of physical props wherever necessary and gives extensive attention to details of the individual poses.

VINI YOGA

This system of yoga as taught by T.K.V. Desikachar is gentle and gradual; it is an individual and progressive system. It is traditionally

taught, on a one-to-one basis, though group classes could be arranged.

There is no set programme and the class is tailored to suit each student. *Vini* yoga practice flows with soft, deep breathing that lasts throughout the duration of the *asana* stretch.

SIVANANDA YOGA

This form taught by Swami Vishnudevananda embraces all yoga paths and is an integrated system based on five principles: proper exercise, correct breathing, proper diet, proper relaxation and positive thinking/meditation. *Sivananda* yoga is a harmonious blend of gentle and progressive methods with rigorous, yet safe and effective physical movements. It is a meditative form with emphasis on breath control and relaxation. This type of yoga is accessible to everyone.

BIHAR SCHOOL OF YOGA

Swami P. Satyananda started this school of yoga where the techniques are a synthesis of many approaches to personal development, based on the traditional yogic teachings. Practice may include *pranayama*, meditation and the study of other classical elements. It has a gentle and therapeutic approach and lays emphasis on scientific understanding of the body and mind.

When beginning yoga, the aim is to find an approach that suits your lifestyle and body type. Explore and look around until you find a style that suits you. Yoga can be adapted to suit the young and the old alike.

3

Philosophy of Yoga

The philosophy of yoga is very simple and anybody can practise yoga irrespective of his or age. Yoga is the oldest traditional science and the only one available to mankind for self-transformation. If its techniques are applied in daily life, you can overcome all the pressures that this age brings and live in a calmer and more thoughtful way.

The renowned sage Patanjali divided *Raj* yoga into eight steps and these steps form the foundation of yogic discipline. These eight steps are also known as *Ashtanga* yoga, as it divides the practices into eight limbs.

By incorporating these basic principles into your day-to-day life and achieving your goals at the same time, you can become a better human being and attain the quest of your soul.

YAMA IS MORAL DISCIPLINE

- *Ahimsa* (non-violence) has an all-encompassing connotation. It means that you must take care not to harm your body, or the

body of any other living being. *Ahimsa* is also practised in thoughts, words and deeds. As you practise yoga daily, you will respect your body and move your postures very gradually and gently.

- *Satya* (truth) – means truthfulness in word, thought and deed. Say what you mean, and mean what you say. Always be truthful to yourself in every matter, your diet and your yoga practice. Remember, if you lie to yourself or the other, the only loser is you and your only achievement will be dissatisfaction.

- *Asteya* (non-stealing) — signifies non-stealing, lack of jealousy, non-covetedness and doing whatever you do, openly. The same goes for your diet and the yoga practice. Release all the thoughts of jealousy from your mind and never indulge in taking what is not yours.

- *Aparigraha* (non-possessive) – means non-possessive, non-accepting. Share whatever you have in the form of knowledge, skills, good thoughts and deeds with others. Be generous in your attitude to others. Help and support those in need. The respect you gain from others will make you love yourself.

- *Brahmacharya* (continence) – literally translated means 'continence' but it really advises moderation in all things. Never over-indulge yourself in anything you do, be it excerise, diet, lifestyle or habits. Always be in full command of your thoughts and actions.

Niyama is Purification of Self through Discipline

- *Saucha* (purity or cleanliness) — represents purity. Treat your body like a temple. Keep it diease-free and clean. Replace all negative thoughts from the mind with good thoughts and feelings for yourself and others.

- *Santosha* (contentment) — means satisfaction. Never ever compare yourself with others. Remember you are special, and the Creator created you uniquely, one of your kind. Be satisfied with yourself, your capabilities and your strengths. Have patience with your limitations, and in time you will achieve all that you set out to do.

- *Tapas* (austerity) — means austerity. Be ready for hard work, as it is this hard work that will help you reap benefits later on. Lead a balanced and disciplined life, and avoid over-indulgence.

- *Svadhyaya* (study of scriptures) — literally means increasing your knowledge in all matters and also following the teachings of your teachers and enriching yourself spiritually. Read inspirational books of courage and truth that movitate and propel you towards a better life. Surround yourself with good people and you will always be positive and fulfilled.

- *Isvarapranidhana* (surrender to the Divine) — signifies surrender to the higher purpose. Put your mind, soul and faith in the work that you are doing without looking for results. Be focused on your goal and you will ultimately achieve it.

When you practise the *yama* and the *niyama*, you control your emotions and passion and keep them in balance for the benefit of your body and mind.

Asana and *pranayama* help your body to breathe and be healthy. Your mind will be trained to be in command of yourself and be stable.

Pratyahara controls your senses and helps you move inwards and discard all that is not good for the body and mind.

The final stages will take you on the journey of 'self' through the art of meditation. You will move inwards to release all negative thoughts and fill your mind with positive beliefs about yourself.

Seers and sages deeply understood that the body has seven vital energy points that link various parts of the body and any shift in these would bring imbalance in the body. These run from the base of the spine to the crown of the head, meaning that we must move up towards the Divine gradually by mastering the pull of the physical world. Let's try and take a quick look at these seven points.

- *MULADHARA* (root support) is located at the lower end of the spinal column. It is a physical body that governs the legs, bones, feet, rectum, the base of the spine and the immune system.

- *SVADISTHANA CHAKRA* (sacral support) is located in the genital organs between the base of the spine and the navel. It is related to sexual organs, large intestine, lower vertebrae, pelvis, appendix, bladder and the hip area.

- *MAINPURA CHAKRA* (solar plexus) is located at the navel and governs the abdomen, stomach, liver, kidneys, adrenal glands, spleen, and middle spine.

- *ANAHATA CHAKRA* (cardiac plexus) is located at the heart centre and governs the heart, lungs, shoulders, arms, ribs and diaphragm.

- *VISHUDDHA CHAKRA* (laryngeal plexus) is located at the throat and governs the throat, thyroid, neck, mouth, teeth, gums and parathyroid glands.

- *AJNA CHAKRA* (cavernous plexus) is located between the eyebrows and governs the brain, nervous system, eyes, ears, pineal glands and pituitary glands.

- *SAHASARA CHAKRA* (crown) is located in the crown of the head and governs the muscular and skeletal system.

Let us undertake this *yogic* journey to discover the perfect harmony in your body and mind. When practising *hatha* yoga, do not neglect the *yama* and *niyama* just because they tend to bring about a change in your lifestyle. Remember, it is through these exercises that you will be able to cultivate a steady mind and body to reach your goal.

4

Yoga and Other Physical Exercises

A regular practice of yoga gives a fit and beautiful body, increases energy and vitality, reduces stress and increases your powers of concentration besides teaching the art of discipline.

Unlike other physical exercises, yoga is gentle. It does not involve the use of rough, intense movements that could cause injury, stiffness and fatigue. Instead, the poses or *asanas* stretch and tone the muscles, joints, the spine and the entire skeletal system. And, with regular practice, increased clarity is experienced along with flexibility, mental power and concentration. This is not so with other forms of physical exercise.

In yoga, the exercises massage and stimulate the internal organs, glands and nerves keeping every cell and tissue rejuvenated and making the body fit, both externally and internally. Correct breathing forms an integral part of the practice of yoga. *Pranayama* or the science of breath control is about using breathing techniques to control the state of the mind. It releases stress from the body,

steadies the emotions and brings great serenity to the mind. Breathing exercises also improve circulation and revitalise the nervous system, with every exercise helping to gradually and systematically lose the extra weight, get the body toned and relaxed and make one feel radiant and energetic.

Yoga opposes the violent movements of the body, whereas the physical culture lays emphasis on violent movements, producing large amounts of lactic acid in the muscle fibres that cause fatigue, muscle stiffness and injury. Actually, yoga helps to awaken and strengthen the body's instinctive ability to improve on its own. Yoga creates a healthy body and a healthy mind, helping to control the faculties of the mind and bring in positive thinking in our lives. Though the results are not instant, they are longer lasting and eventually become permanent.

5

Yoga – The Natural High

Due to the pressures that life has in store for youngsters, their inability to be competitive in life and failure to meet the desired results in life lead can lead them to depression. This is a natural part of being a teenager, and it's not easy. They often turn to mind-altering and mood-altering drugs. The reason for which they turn towards these drugs could be the desire to increase the energy level, relax and lower the stress level, to reach a blissful state and the higher levels of consciousness.

The youngsters will stoop to any length to get their mind and body relaxed, and it is amazing that drinks and drugs are so pervasive in our culture. The young do not even stop to consider the cost and benefit ratio of different ways of getting high.

Alcoholism is one of the most common and serious problems among youngsters, as it is easily available to them. The long-term use of alcohol has a debilitating effect on the liver, brain, heart, pancreas and the immune system. Drinking depresses the biological system to a point of shutting down the breathing reflexes. When the alcohol content rises in the blood, it disables the functioning of the brain and a person loses his ability to respond to the senses.

Stimulants are also very common among youngsters as these enchance their energy level, which is what they require in their busy and demanding lifestyle. The stimulants provide a bit of energy and elevate the mood, but can only churn out only a limited amount of bio-chemicals before crashing, as the brain sends signals for more. Extended use can damage the brain very seriously.

This is where that yoga can and will benefit the youngsters as it is a complete science of life that originated in India many thousands of years ago. It is the oldest system of personal development in the world, encompassing the body, mind and spirit. Yoga and meditation produce all the results that one wants to experience without the harmful effects of drugs. Yoga *asana* and meditation methods are very relaxing. Yoga postures tone and invigorate the physical organs. Meditation provides focus and objective that help you face problems in life, rather than running away from them, by taking to drugs. Yoga is a way to energise and increase the stamina you need in your daily and active, busy schedule.

6

Asana

The *Yoga Sutra* defines *asana* as *sukham sithartam,* a posture that is comfortable, easy and steady. Yoga teaches that each posture reflects a mental attitude and benefits the internal and external body.

There are about eighty-four *asanas* commonly used by *yogis,* but we can benefit from a dozen of them. Many *asanas* have animal names, as *yogis* devised each *asana* by observing the movements of animals and how their instinct in the wild influenced their bodily movements. Observe how your pet dog and cat move their body, on awakening from sleep—they instinctively stretch, arch the spine in both directions and then relax.

Asanas are also based on a sound knowledge of human anatomy and physiology. The *yogis* knew exactly that placing of the body in certain positions would stimulate specific nerves, organs and glands. The inverted postures increase the circulation of blood to the brain, thus stimulating the brain nerves, increasing vitality and brain functions so as to build intelligence and memory.

17

The *yogis* knew the vulnerability of the spine and that as we age, the spine loses its flexibility and deteriorates. This further leads to the deterioration of the organs and the glands and the body gets diseased. The *asanas* have a profound effect on the thyroid, pituitary, pineal, adrenal, pancreas and the sex glands. The function of these glands is to secrete powerful hormones that control a youngster's growth, weight and size. They also determine the metabolism, vitality and emotional state. Apart from this, *asanas* strengthen the heart and help in proper digestion and assimilation of the food that is eaten. The stretching that is done with each *asana* lubricates the joints, making it supple and releases all the toxins from the area, thus preventing its stiffness. Apart from all this, yoga postures help teenagers to balance their emotions, relax their minds, strengthen their concentration and improve their memory. Regular practice of yoga *asana* helps to clear the skin from pimples and the blemishes that come as a package deal at this age, due to hormonal imbalances experienced on sexual maturing. Certain poses help in alleviating menstrual cramps, increase in height and in giving a perfect body.

The *asanas* are based on five basic principles and these are:

- Use of gravity: The inverted posture such as shoulder stand takes advantage of gravity to increase the flow of blood to the desired part of the body and activate the thyroid gland.

- Stretching the muscles: This causes an increase in blood supply to the muscles and relaxes the muscles. It also takes pressure off the nerves in the specific area. This stretching is involved in all *asanas* and benefits the body.

- Organ massage: The position of *asana* causes a squeezing action on a specific organ or gland, stimulating that part of the body.

- Deep breathing: While doing and retaining the yoga posture we breathe deeply and slowly, moving the abdomen. This increases oxygen supply to the pressed organ or gland, thereby enhancing the effect of the *asana*.

- Concentration: While doing the yoga posture, focus the attention on the organ or gland. This brings the mind into use and increases the blood circulation in the area; but more importantly, increases the powers of concentration. This has a profound effect on our life. We start to live in awareness and the mind gets less distracted or swayed by external events.

Therefore, it becomes important for all teenagers to practise yoga regularly as it will help them to stay in perfect balance in this fast-changing world. They will excel in all that they do and will be in a better position to face challenges in their life with a sound mind and body.

7

Let's Do Yoga

If you have never practised yoga before, you will need to follow some simple but important guidelines to get the most out of your yoga sessions.

- Find a suitable, well-ventilated room. Try to set aside a specific time each day for the yoga session.

- A sticky mat is the perfect surface for yoga postures because it keeps the *yogi's* feet, hands and elbows from slipping, allowing one to stretch to your potential.

- Avoid *asanas* during menstrual periods.

- Do not eat for two hours prior to the yoga session.

- Dress in loose, comfortable clothing, preferably cotton, as the body needs to breathe during the sessions. Leave the feet bare and remove your watch or any jewellery that you may be wearing.

- Put on some light music, as it will be soothing and will help to take your mind off the discomfort you may experience during stretching.

- Remember you don't have to be thin, trim and lean to practise yoga. Change the yoga postures to suit your figure and condition. Don't go for the burn out, but start slowly and push yourself only as far as you are comfortable with. Flexibility will develop with time. Start with a few minutes of gentle movements and then deepen your practice.

- If practising on your own is a little difficult, team up with a few friends and practise with them, but remember never compete with the friend practising with you. Always move at your own pace and practise each pose as best you can. Introduce the element of fun in your practice.

- Remember yoga begins from where you are, no matter in what condition your body is or whatever is going on in your mind. Just keep an open mind and focus on the present.

- Breath is the essence of yoga practice and the key to relaxation, so do not forget to breathe. If your breath gets exaggerated or when the body fights for breath, it is a sign that you are going past your body's capacity. Always inhale and exhale from the nostrils while practising postures. Relax for a few seconds after each *asana*, breathing deeply and slowly.

- Relax in *shavasana* after each posture and breathe deeply.

- Try and hold the posture for as long as the body feels comfortable, and practise on your own pace, never jerking or straining your body while doing the *asana*. Be patient. It takes time for the body to respond, especially if some of you have

never done any form of excerise. The body will be stiff, which is the result of toxins accumulated in the muscles.

Remember to promise yourself that you will be tender and loving with your body.

While practicing let go of all your physical, emotional and mental stiffness like fear, anger and hatred.

If you are not confident to start the practice on your own, join a yoga studio and later continue your practice on your own.

Remember you don't have to contort the body into any awkward positions when you practise yoga. In the daily routine, you are basically clearing the mind and learning to breathe. With regular practice of yoga, a perfect mind and body can be built.

Surya Namaskar (Sun Salutation)

Surya namaskar is an important part of yoga practice. It is a series of 12 continuous postures practised as a flowing series. It is always good to begin the yoga session with a few rounds of *surya namaskar* as it stretches all parts of the body muscles, generating heat and warming the muscle tissues while helping the body to become flexibile. At the same time it protects the body from any injury. It is also a very good cardiovascular exercise to improve the circulation of blood throughout the body.

Surya namaskar improves the overall body strength and builds stamina. It is the best yogic exercise as both the benefits of *asana* and *pranayama* can be attained in this series of 12 postures. Sun salutation should be ideally done early in the morning, facing the sun and each movement of the body is synchronised with one's breath. However, if that is not possible, then it may be practised at any time on an empty stomach.

Let's Start

Begin by standing straight up, with legs together and your arms by the side of your body. Close your eyes and become aware of your whole body. Begin to relax your body mentally.

Position 1
Exhale. Join your palms together in a *namaskar* position in front of your chest and mentally pay your respects to the Sun God: *Aum surya namah.*

24

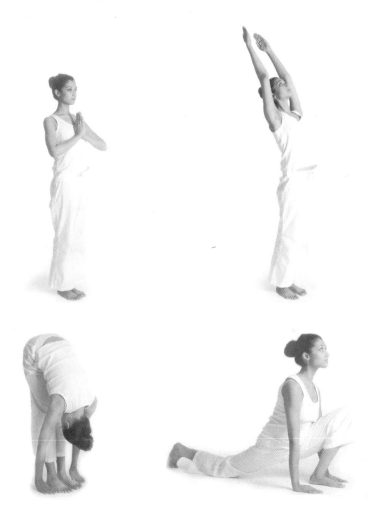

Position 2
Inhale. Stretch your arms straight above your head, arching your body backwards. Knees and elbows should be straight and your arms on either side of your ears.

Position 3
Exhale. Slowly bend forward, bringing your hands to the floor, next to your feet. Try to touch your forehead to your knees, keeping your knees straight. Don't strain.

Position 4
Inhale. Without moving your hands, stretch your right leg backwards as far as possible. Placing your right knee on the floor, stretch your head upwards.

Position 5
Exhale. Move your left foot in position beside your right foot. At the same time, lift your hips and lower your head between your arms so that your back and legs form a perfect triangle. Push your heels towards the floor and your palms should be flat on the floor.

Position 6
Retain your breath. Dip your knees, chest and chin or forehead to the floor, lifting your hips and abdomen up. If this is difficult initially, then lower your knees first, then your chest and finally your chin before moving your hips up.

Position 7
Inhale. Slide your body forward till your hips are on the floor. Arch your back and chest upwards and drop your head back. Your legs,

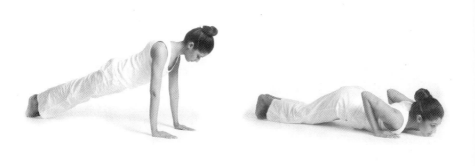

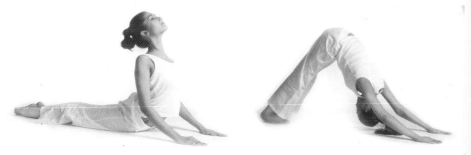

hips and hands remain on the floor.

Position 8
Exhale. Tuck your toes and without moving your hands and feet, lift your hips as high up as possible and lower your head between your arms, so that your body forms a triangle.

Position 9
Inhale. Bring your right foot forward between your hands so that your fingers and toes are lined up together. Move your left leg back with knees touching the floor. Stretch your head upwards.

Position 10
Exhale. Without moving your hands, bring your left leg forward next to the right foot, hands close to your feet and forehead on your knees.

Position 11
Inhale. Stretch your body up and arch backwards.

Position 12
Exhale. Bring both the palms together in a *namaskar* at chest level.

Relax.

These 12 positions are practised twice to complete one round of surya namaskar, *with the right and left legs alternatingly coming forward and moving backwards.*

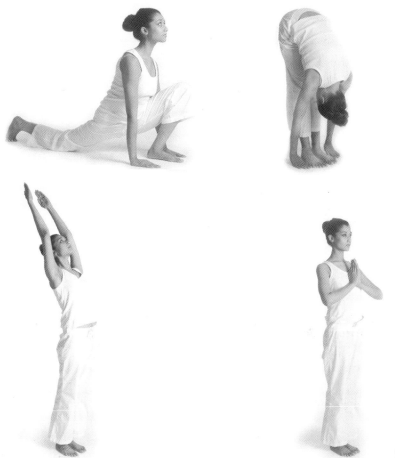

29

8

Memory and Concentration

Yoga techniques stimulate the brain and the nervous system and help to improve the memory and concentration. The *asana*, especially the balancing posture improves the mental concentration by fixing the gaze or *drishti* during the practice at a point. The mind is withdrawn towards the flow of breath during the practice of postures. *Pranayama* increases the oxygen in the body and nourishes the brain to improve concentration.

Mediation, is "one, pointed total concentration" and the regular practice of mediation will unclutter the mind and reduce excessive thinking, as it is the excessive thinking that consumes all the mental energy and fogs the mind from seeing and thinking clearly. Meditation on the sixth *chakra*, the point between the eyebrows, activates the brain and keeps the mind focused, improving the memory.

The exercises taught in the following pages will activate the spinal column, stimulate the nervous system, and help in mental concentration.

VIRKASANA (TREE POSE)

The tree pose is an excellent pose to improve balance and concentration; it strengthens the muscles of the legs and the pelvis, opens the chest and shoulders and improves the quality of the breath.

- Stand with feet together, arms by the side and head straight.
- Bend the right leg at the knee and place the right heel firmly at the root of the left thigh, toes pointing downwards.
- Balance on the left leg, join the palms and slowly raise the arms over the head.
- Focus the eyes on a stationary point on the wall and hold the posture for a few seconds, breathing normally.
- Release the posture by placing the right leg and arms down and repeat the same on the left side.

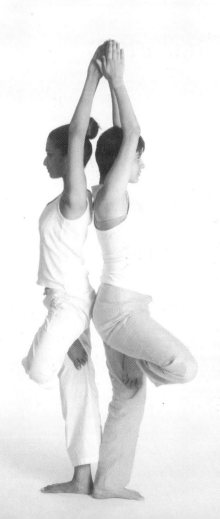

GARUDASANA (EAGLE POSE)

This posture strengthens the leg muscles, helps in improving memory and builds concentration. It also helps in toning the nerves of the spine and brings balance to the mind, resulting in mental clarity.

- Stand straight in *tadasana*.
- Bend the right knee, and bring the left leg over the right thigh above the right knee and rest the left thigh in front of the right thigh. Breathe in this position for a few seconds, keeping the eyes fixed at a point on the floor or on the wall.
- Now move the left foot behind the right calf, so as to touch the left foot to the right shin bone. Remember to balance the entire body weight on the right leg.
- Raise the arms to the level of the chest and bend the elbows. Place the right elbow in front of the left upper arm near the elbow joint and join both the palms together.
- Hold the posture for a few seconds while breathing deeply and then release the posture. Repeat the pose, standing on the left leg.
- Take care to keep the eyes fixed at a point for balance.

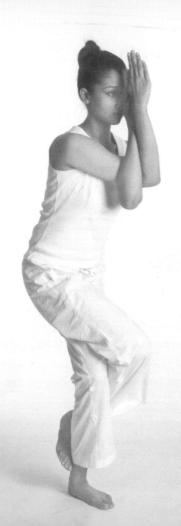

NATARAJASANA (LORD SHIVA'S POSE)

It brings balance to the entire nervous system, develops control of the body and brings mental concentration, releasing all stiffness in the legs, the hip muscles and making the hip and spine supple.

- Stand with the feet together, spine and head held straight and arms by the side, close to the body.
- Focus the gaze at a fixed point at eye level and relax the body, breathing normally.
- Bend the right knee and hold the ankle with the right hand behind the body.
- Keep both knees together and maintain your balance. Slowly raise and stretch the right leg backwards, as high as possible, and till it is directly behind the body.
- Raise the left arm upward and forward.
- Hold the posture for as long as possible, breathing normally.
- Release the posture, by lowering the left arm to the side and the right ankle and foot on the floor, arms by the side, close to the body.
- Repeat the same on the left leg.
- Take care to keep the knee-caps pulled up and the leg stretched straight.

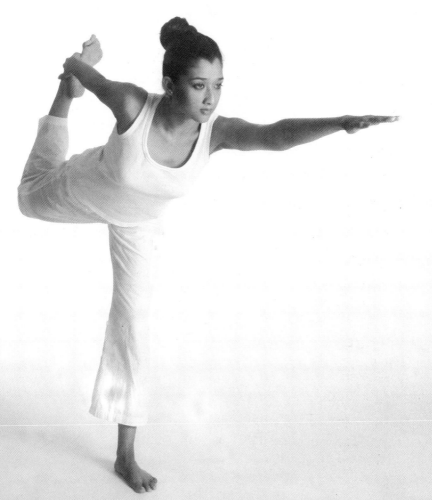

UTTHITA HASTA PADANGUSTHASANA (EXTENDED HAND AND FOOT POSE)

The regular practice of this *asana* improves concentration and co-ordinates muscular and nervous balance. It also tones the hips and the legs and helps in increase of height, making the body strong and poised.

- Stand with feet together, spine and head held straight and arms by the side, close to the body.

- Relax the entire body and breathe slowly and deeply.

- Exhale. Raise the right leg by bending from the knee and hold the big toe of the foot.

- Place the left arm on the hip and maintain balance of the entire body. Stretch the right leg forward and straighten the knee, if possible.

- Hold the posture for 20 to 30 seconds or as long as comfortable, while breathing deeply.

- Release the posture, and repeat the same with the left leg.

- Take care to move into the posture slowly and with regular practice.

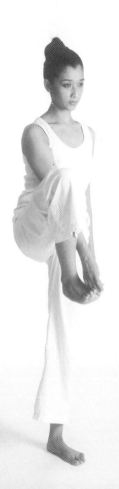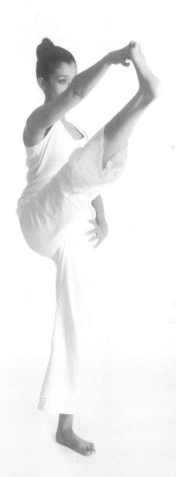

39

Figure Correction

Correct posture is a simple and very important way to keep the spine healthy. Not maintaining a good posture puts strain on the muscles and the spine. Over a period of time this could lead to suppression of the spinal nerves and changes in the anatomical structure of the spine. The result is regular neck pain, headache, and fatigue and possibly it even affects the major organs and the breathing system.

When a girl begins to develop breasts, the muscles that hold the spine are often weakened or strained, because the front of the torso is carrying more weight. Young girls are embarrassed at the growing body and in order to hide the breast they slouch forward and the shoulders get rounded.

If the poor posture is not corrected, you will get used to this posture and never tell yourself to stand up straight. And it is here that yoga posture can really help, as the main focus in yoga is on a healthy spine. All the *asanas* are designed to stimulate the nerves that run down along the entire spine. With regular practice you will gain flexibility, tone the entire body, resulting in a well-sculpted and proportioned body.

PADAMASANA (LOTUS POSE)

This is one of the meditative positions that relaxes the entire body. It is a good cure for stiff knees and ankles and nourishes the spine with a good circulation of blood.

- Sit on the floor with legs stretched forward.

- Bend the right leg from the knee, holding on to the right foot with the hand, place it on the root of the left thigh, and touch the right heel near the navel.

- Now bend the left leg from the knee, and place the left foot at the root of the right thigh with heel near the right navel.

- Place the hands on the thighs in *chin mudra* (thumb touching the index finger).

- Keep the spine straight and neck relaxed with chin parallel to the floor. Close the eyes and hold the posture for as long as comfortable. Change the leg position by bringing the left foot over the right thigh.

- Take care to practise the posture gently and with regular practice one can sit in this position for a long time.

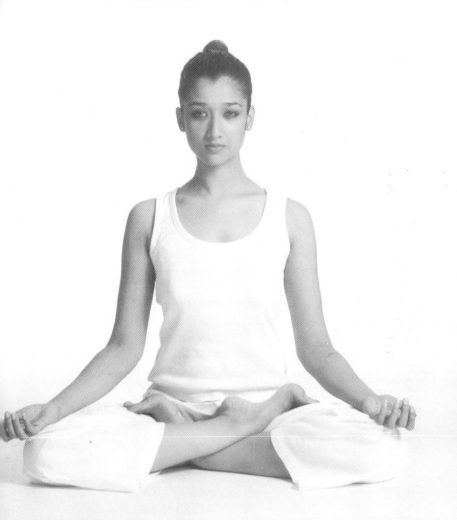

43

VIRABHADRASANA (WARRIOR POSE)

The regular practice of this *asana* will strengthen the leg muscles making them very strong, releasing cramps in the calf and thigh muscles, toning the hips, arms and the thighs as also the abdominal organs.

- Stand with feet together, spine and head held straight and arms by the side, close to the body.
- Separate the legs 4 to 4.5 feet apart.
- Raise the arms sideways in line with the shoulders, palms facing downwards and parallel to the floor.
- Turn the right foot 90 degrees to the right and the left foot slightly inwards to the right. Keep the left leg stretched out and tightened at the knee.
- Hold the posture and breathe deeply and relax the body in this position.
- Exhale. Bend the right knee till the right thigh is parallel to the floor and the right shin perpendicular to the floor. The bent knee should not extend beyond the ankle, but should be in line with the heel.
- Turn the face to the right and gaze at the right palm.
- Hold the position for 20 to 30 seconds with deep breathing.
- Release the posture by lifting the body up and straightening the knee.
- Repeat the same on the left leg.

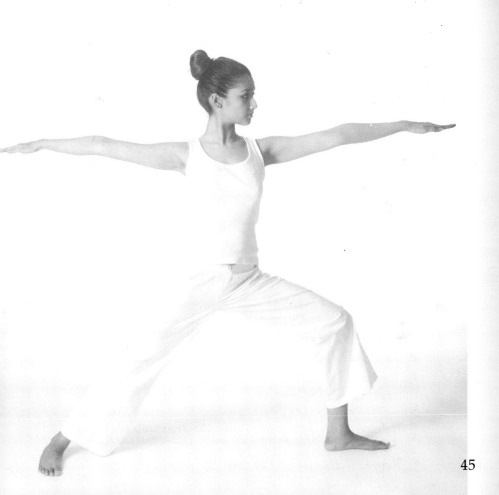

PARVRITTA PARSVAKONASANA (REVOLVING LATERAL TRIANGLE)

The practice of this *asana* removes all deformities and stiffness from the legs and also helps increase height while giving a good shape to the legs.

- Stand with feet together, spine and head held straight and arms by the side, close to the body.
- Separate the legs 3 to 3.5 feet apart, raise the arms sideways in line with the shoulders, palms facing down and parallel to the floor.
- Turn the right foot 90 degrees to the right and the left foot slightly inwards to the right.
- Inhale. Elongate the spine and rotate the torso towards the right.
- Exhale. Bend forward and bring the left palm on the floor near the outer side of the right foot, stretch the right arm up, gaze at the right thumb, stretching the shoulders.
- Hold the position for 20 to 30 seconds, breathing normally.
- Inhale. Lift the left arm from the floor, rotate the torso back and release the posture.
- Repeat the same on the left side.
- Take care to keep the knees tight and balance the body weight on the ankles and toes.

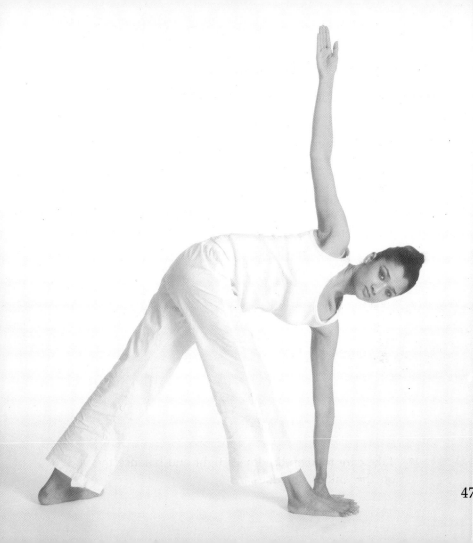

47

Prasarita Padattanasana
(Extended Leg and Foot Pose)

The practice of this posture strengthens the hamstring and abductor muscles, giving a good supply of blood to the head and the trunk and the digestive system gets toned.

- Stand with feet together, spine and head held straight and arms by the side, close to the body.

- Separate the legs 4 to 4.5 feet apart and place the arms on the waist. Tighten the legs and draw the knee-caps up.

- Exhale. Bend the torso forward and place the palms on the floor in line with the shoulders between the feet.

- Inhale. Raise the head up, keeping the back concave.

- Hold for 20 to 30 seconds, breathing deeply.

- Take care to keep the weight of the body on the legs and keep the knee-caps tight.

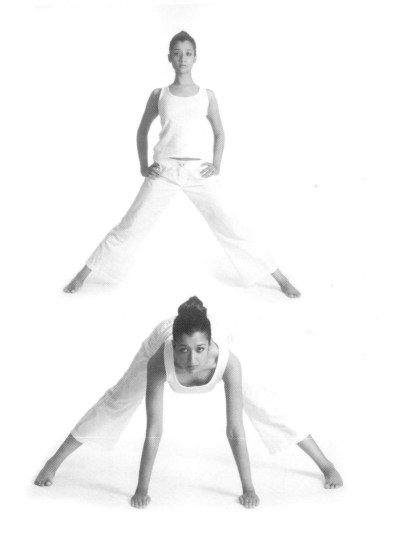

49

Chandra Asana (Half-Moon Pose)

The practice of this *asana* tones the entire body, expanding the chest fully and thus helping in deep breathing. It relieves stiffness from the shoulders and the spine, tones the ankles and knees and helps reduce fat around the hips and thighs.

- Stand with feet together, spine and head held straight and arms by the side, close to the body.

- Exhale. Bend forward until the palms touch the floor on either side of the feet.

- Place the palms on the floor, bend the left knee, keeping the left foot firmly on the floor. Simultaneously stretch the right leg back, touching the knees with toes on the floor.

- Relax the entire body in this position, breathing normally.

- Maintain balance of the body. Raise the arms up and bring the palms together in front of the chest in *namaste* position.

- Inhale. Raise the arms over the head, keeping the palms together.

- Arch the spine and look up towards the palms, raising the chin up.

- Hold the posture for 20 to 30 seconds, breathing normally.

- Exhale. Bring the arms down and place the palms on the floor, close to the left foot and change the position of the leg. Repeat the same on the left leg.

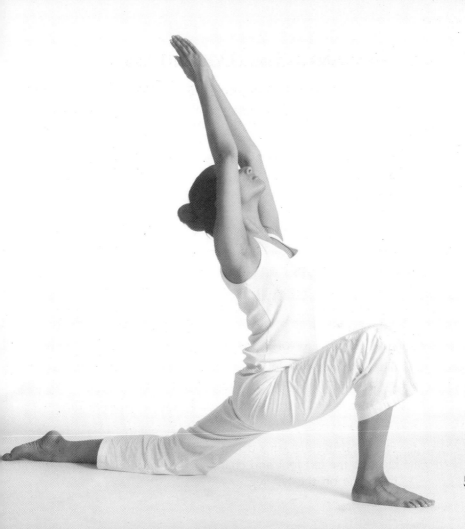

51

Supta Virasana (Lying Down Warrior)

The practice of this *asana* will improve the lungs and relieve all chest ailments. The body will become proportionate and beautiful. The abdominal organs and pelvic region are stretched.

- Kneel on the floor, keep the thighs and feet together, toes pointing back and resting on the floor.

- Separate the feet 8 inches apart. Place the hips on the floor, arms resting on the thighs. Relax the body in this position, breathing deeply.

- Exhale. Recline the torso back by holding the ankles. Rest the elbows one by one on the floor to relieve the pressure on the elbows and extend the arms.

- Rest the crown of the head on the floor, while resting the back of the head and then the spine on the floor. Expand the chest, take the arms over the head and stretch them out straight.

- Hold the posture for 20 to 30 seconds, breathing normally.

- Inhale. Placing the arms besides the trunk, press the elbows on the floor and sit up to release the posture.

- Take care if you are new to yoga. In that case, keep the knees apart.

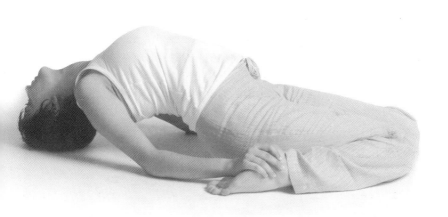

Ustrasana (Camel Pose)

The camel pose is very beneficial to all youngsters who suffer from respiratory problems like asthma and bronchitis, as it expands the chest and fills the lungs with an abundant supply of oxygen. It aids the digestive and reproductive systems, releases stiffness from the spine, stimulates the spinal nerves, corrects drooping and round shoulders and makes the posture perfect.

- Kneel on the floor, keep the thighs and feet together, toes pointing back and resting on the floor. The knees can be kept slightly separated, if desired.

- Support the spine with the palms. Inhale. Lean backwards pushing the hips and abdomen forward and expand the chest and shoulders, dropping the neck backwards.

- Exhale. Release the right palm and move down to hold the right ankle and the left palm to hold the left ankle.

- Hold this position for 20 to 30 seconds, breathing normally.

- Inhale. Lift up and release the posture.

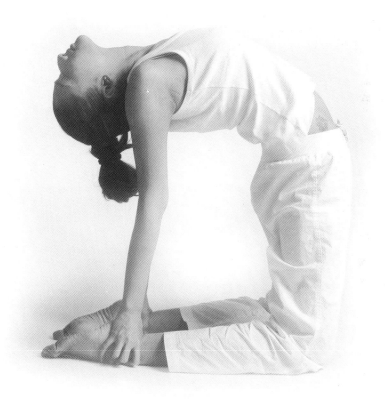

BHUJANGASANA (Cobra Pose)

This exercise relieves indigestion and constipation and helps in elimination of waste. It removes backache and makes the spine supple and healthy. It also tones the ovaries and the uterus, and helps to remove gynaecological disorders. It is very beneficial for all abdominal organs, helps in toning hips, thighs and calf muscles.

- Lie on your stomach with forehead touching the floor and your legs and heels held together.
- Place your palms flat on the floor, directly below the sides of your shoulders with fingertips in line with the top of your shoulders.
- Your elbows should be bent, pointing upwards and inwards.
- Inhale. Raise your neck and shoulders by pushing upwards and straightening your elbows.
- Try to raise your body as high as possible, using your back muscles. Drop your head backwards.
- Stay in this position for 20 to 30 seconds, breathing normally.
- Exhale slowly as you gently lower your body to release the posture. Relax.
- Take care to contract the lower body as tight as possible.

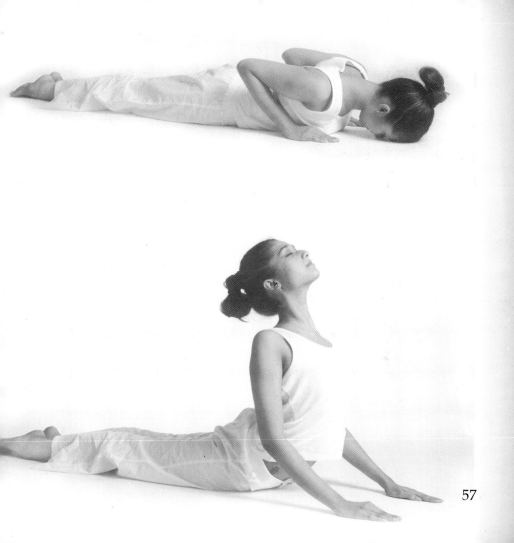

Salabhasana (Locust Pose)

This *asana* is very good for stretching the spine, making it elastic and relieving pain in the sacral and the lumbar regions. It is most beneficial for students suffering from low backache. This *asana* also aids in digestion and helps to tone the entire body.

- Lie on the abdomen, clasp the hands together to make into fists, and place them between the thighs. Stretch the chin forward and place it on the ground.
- Inhale. Raise the right leg off the floor, as high as possible, without bending the knee; hold this position for a few seconds. Exhale and lower the right leg down.
- Inhale. Raise the left leg off the floor, as high as possible, without bending the knees and hold for a few seconds. Exhale. Lower the left leg down.
- Inhale deeply and raise both legs high as possible. Hold still for a few seconds and bring the legs down.
- Take care to keep the chin pressed to the floor.

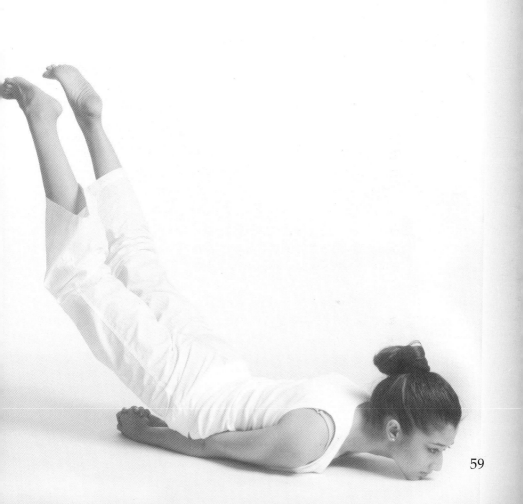

59

10

Premenstrual Syndrome (PMS)

Premenstrual syndrome occurs a week before the start of the normal menstrual cycle, causing a lot of emotional and physical problems. The most common symptoms of PMS are mood swings, breast tenderness, bloating, blemishes, weight gain and fatigue. Due to hormonal changes, there is a shift in the level of serotonin—a brain chemical that regulates many functions including mood swings and pain in various parts of the body. It also affects the energy level of the body making the girls feel weak.

The best way to deal with PMS is to adopt self-help measures which include a low-fat, high-fibre diet that is rich in fruits, vegetables and whole grains, a good exercise routine and supplements. Regular practice of yoga postures provides immediate relief from the discomfort of PMS. Regular practice of *pranayama* will increase the energy level in the body while the meditation techniques will calm the body and mind and ease the premenstrual symptoms.

In these following pages we have illustrated the *asanas* that will tone the reproductive organs and if done regularly, the symptoms of PMS will lessen and in some cases disappear completely.

KURMASANA (TORTOISE POSE)

This *asana* increases the flexibility of the hips, inner thighs, pelvis, lower back, knees and the ankles. It tones the reproductive organs and is also very helpful for correcting menstrual problems.

- Sit on the floor with legs together and stretched out in front of you.

- Place the palms on the floor by the side of your hips and keep your spine erect.

- Bend your knees, join the soles of your feet together, move the feet 6 to 8 inches further from the pelvis, keeping the soles of the feet together.

- Inhale. Elongate the spine. Exhale. Extend forward from the lower spine and touch the elbows on the floor, taking the hands from under the ankles. Holding on to the toes with both the palms, touch the forehead on the joined toes.

- Hold this position for 20 to 30 seconds.

- Inhale, and raise yourself to release the posture.

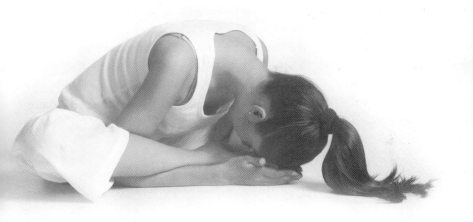

GARBHASANA (FOETUS POSE)

The foetus pose makes the entire body beautiful and the face radiant as it increases the intake of oxygen in the body, clearing the skin of pimples. It also releases all the menstrual pains and makes them regular.

- Sit in *padamasana* as shown in the adjoining page.
- Insert the arms through the space between the calf and thighs. They should go as far down so that the elbows emerge from below the calves and the thighs.
- Inhale. Raise the knees towards the shoulders or as far as possible and rest the hands on the jaws, balancing the body on the hips.
- Hold the posture for 20 to 30 seconds, breathing normally.

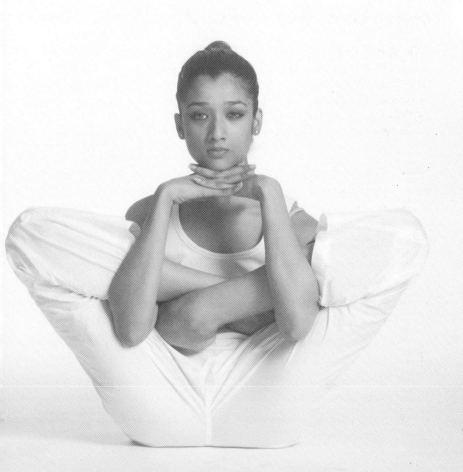

Ardh Matyasenderasana (Half Spinal Twist)

The spinal twist rejuvenates the nerves of your spine and makes your back flexible. It massages the abdominal organs and rids the body of the toxic by-products of digestion. It regulates the secretion of adrenaline and bile and is extremely helpful in menstrual disorders, urinary tract infection and colitis.

- Sit on the floor with legs together and stretched out in front of you.
- Place the palms on the floor by the side of the hips, fingers pointing to the ankles. Keep your spine and head straight.
- Bend the right leg from the knee and place the right ankle close to the left outer thigh. Bend the left knee and place the left ankle close to the right hip.
- Stretch your right arm up and bring it behind your back, palms on the floor, to support and keep the spine straight.
- Stretch your left arm up and bring it over the right side of your right knee. Reach out and hold your right ankle.
- Look over your right shoulder. Breathe deeply in this position for 20 to 30 seconds.
- Release the posture and repeat the same sequence on the left side of your body.
- Take care to understand that the twist is from the spine and not the neck.

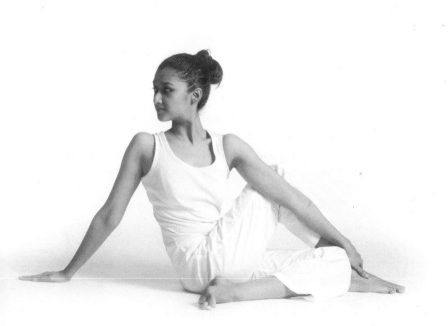

SARVANGASANA (SHOULDER STAND)

This posture is particularly good for young girls. It is beneficial for urinary disorders, menstrual irregularities and also has a very positive effect in balancing your hormones.

- Lie flat on the floor with your legs together, arms by your sides and palms facing the floor.
- Inhale. Raise both your legs until they are at right angles to your body. Then slowly raise them even further by gently lifting your hips and back from the floor while you support yourself by pressing your palms on the floor.
- When your legs are raised, support your spine with your hands, resting your shoulders on the floor. Stay in this position for 20 to 30 seconds, breathing normally.
- Slowly ease your raised torso forward with the help of your palms so that your breastbone makes contact with your chin to form a chin-lock. This will stretch your spine completely and the full benefit of the *asana* will be achieved.
- To release the posture, bend your knees forward to your forehead and gently lower your body down.
- For the chin-lock, bring your chest forward to touch the chin and not the other way around, i.e. do not push your chin outwards to meet your chest.
- Take care when supporting your back, bring your elbows as close to each other as possible, keeping shoulders away from the neck.

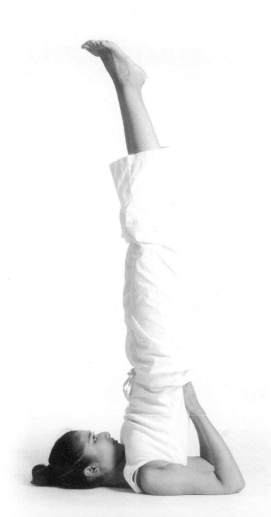

HALASANA (PLOUGH POSE)

This *asana* tones your entire lower body. It benefits the abdominal organs, relieves pain in the back as your spine will receive a good supply of blood. It also releases the stiffness in the shoulders, elbows and back besides removing laziness from the body. The mind becomes clear and calmer and the ability to remain focused will increase.

- This *asana* is a straight continuation from *sarvangasana*.

- Gently bring both legs down but towards the back of your head, keeping your back continuously supported with your palms.

- Touch your toes on the ground behind your head, transferring your weight to your toes.

- Straighten your legs by keeping your knees straight. Make sure that your toes are inward, toward your head and your heels are pointing up.

- Contract your hip muscles and pull in the abdominal muscles.

- If your toes are firmly supporting your weight, slowly release your arms (which were supporting your back) and place them flat on the floor and parallel to each other. Hold the posture for a few seconds.

- To release the posture, come back up into the *sarvangasana* position and then slowly bring your body to its original position.

- Take care not to push the body too far. Move gently and take all the time you need to come into this posture.

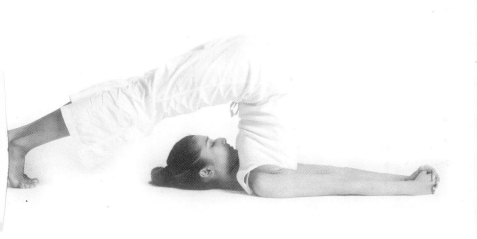

Setubandhasana (Bridge Pose)

This *asana* is excellent for the muscles of the hips, thighs and calves. It increases the flexibility of your spine and massages the liver and spleen. It tones the reproductive organs.

- This *asana* can be done in a straight continuation from *sarvangasana*.
- Rest the palms firmly on the back, raise the spine up and bend the knees. Throw the legs back one by one over the wrists to the floor. The whole body forms a bridge; the weight is taken on the elbows and the wrists. Keep the heels firmly on the floor.

If you are new to yoga then begin from:

- Lie flat on your back with legs together.
- Place your arms by your sides with palms facing the floor and head straight.
- Bend your knees, bring them up halfway toward your hips with your feet firmly on the ground.
- Using your palms to support your lower back, lift your hips off the floor. Hold this position, breathing normally.
- Keeping all the weight on the left side of the body, inhale and raise the right leg up, holding for a few seconds. Exhale. Lower the leg down and lift the left leg up, hold for few seconds and then release the posture by bringing your hips and arms back to the starting position.

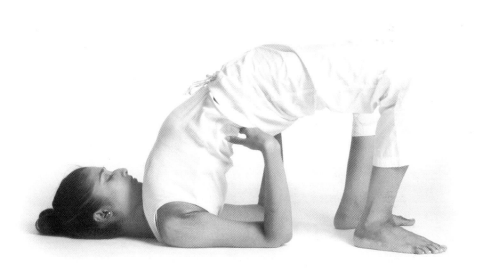

11

Radiant Look

Due to the hormonal changes in the body and the stressful life that the teenagers lead, the affects are felt on the texture of the facial skin. There are sudden bursts of pimples and growth of facial hair, dark circles under the eyes. Stress and worry easily appear on the face making the face dull and lifeless; if you are in love and are happy, the cheeks glow and blush, and the skin will shine.

So it's no surprise that your health status can easily be read on your face. Sedentary lifestyle, poor nutrition and illness will show up as dull, lifeless skin. Yoga postures help in making the internal body strong and function to their optimum level with the body releasing the toxins in the form of sweat. Another way to ensure a smooth, healthy complexion is by eating a healthy diet, which is full of fresh and natural foods that will supply the body all the vital nutrients and nourish the body and skin.

Young girls must understand that beauty is all about perfect balance of the mind and body; they must try and cultivate their inner beauty and good health. That's the secret of true beauty.

MATSYASANA (FISH POSE)

The fish pose gives a good stretch to your back and neck. Regular practice also reduces throat ailments and improves skin texture, making you look radiant. Moods, emotions and stress are regulated.

- Lie down, flat on your back, with your legs straight out. Place your hands and palms underneath your hips and thighs so that you are sitting on them.

- Inhale. Bending your elbows, push away from the ground, lifting your chest until you are sitting half way. Raise your head up and look towards your toes.

- Exhale. Arch your back, expand your chest and drop your head backwards down, towards the ground. Touch the crown of your head to the ground. Hold this position for a few seconds, breathing deeply to take in enough oxygen into your body.

- Inhale. Raise the right leg up, exhale and bring the leg down. Repeat the same with the left leg.

- To release the position, inhale. Lift your head up and place it on the floor. Release your arms and relax the body.

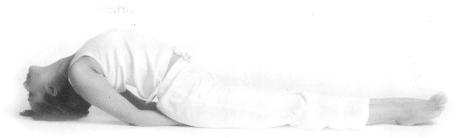

Pada Hastasana (Standing Forward Bends)

This *asana* invigorates the entire spine and the nervous system. It increases the blood supply to your brain and is an excellent posture to nourish the skin.

- Stand straight with feet together and toes touching.
- Inhale. Raise both arms straight up over your head. They should be touching your ears.
- Exhale. Stretch your body forward, bending downward from your hips. Keep your knees tight.
- Touch your forehead to your knees and hold both ankles with your hands from behind.
- Stay in this position for as long as comfortable, breathing normally.
- Inhale. Slowly come up and release the position.
- Make sure that the weight of your body is centred on the balls of your feet. Stretch your hips upwards during this posture and keep your knees straight.

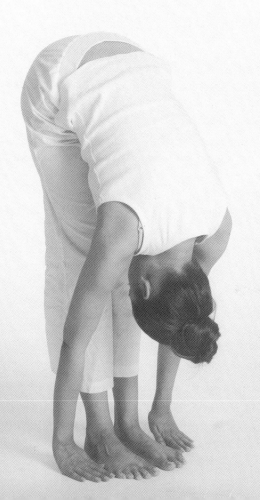

79

CHAKRASANA (WHEEL POSE)

The *chakrasana* is a great all-round toner. It stretches your spine and reduces the stiffness. This *asana* has a wonderful effect on the nervous, digestive, respiratory and cardiovascular systems. It relieves the body of many gynaecological disorders.

- Lie flat on your back with the legs together.
- Raise your arms, bend them backwards and place your palms on the floor, on either side of your head. Your fingers should be pointing towards your feet, fingers facing your feet.
- Keeping your feet on the floor, bend your knees and bring your feet towards your body till your ankles touch your buttocks. Keep your feet and palms comfortably wide apart.
- Lift your hips upward, pressing down on your hands and resting the crown of your head on the floor. Rest briefly.
- Raise your body slowly, arching your head back so that your palms and the soles of your feet support your weight.
- Slowly straighten your arms, lifting your head off the ground and raising your hips high.
- Hold the position as long as you feel comfortable.
- Release the posture by bending your knees and elbows and lowering your body to the floor.
- Take extreme care not to push yourself beyond your body's capacity. Do two sequences if you can.

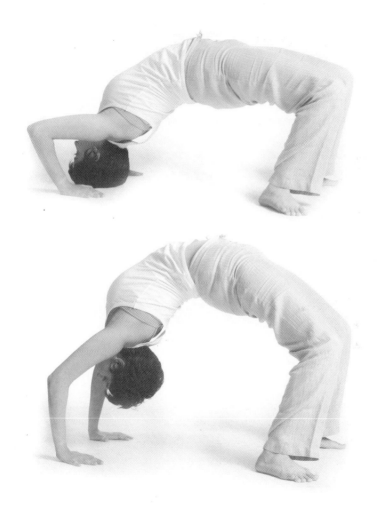

12

Combating Stress

As students you have to strive too hard academically due to increasing competition. The other reasons for stress could be changes in the physical appearance, problems with friends, separation from parents or loss of loved ones. The effects of stress are tremendous: the physical and mental tension weakens the body's resistance to disease, making the young girls prone to illness. Digestive problems such as constipation and indigestion may increase; it may even aggravate diseases such as diabetes and asthma.

The techniques taught in yoga are the best way to deal with stress and anxiety. Yoga postures will activate and move the *prana* energy in the body, and open all the energy points, stimulating the nervous system and balancing the mind and spirit. Practice of breathing techniques energises the body and reduces the stress level in the body, as the slow, effortless breathing triggers a sense of calmness and releases tension from the entire body.

Yoga *Mudra*

This posture relieves the toxins that gets accumulated in the body and increases digestion. It reduces stress and helps in bringing peace and tranquillity.

- Sit in *padamasana* as shown in the adjacent page.
- Raise the right arm up and swing it back from the shoulders to bring the hand near the left hip. Try to catch the left big toe with the fingers or simply stretch the shoulders back.
- Similarly, raise the left arm up and swing it back from the shoulders and bring the hand near the right hip. Try to catch the right toe with the fingers or simply stretch the shoulders back.
- Hold the posture for 20 to 30 seconds, breathing normally.

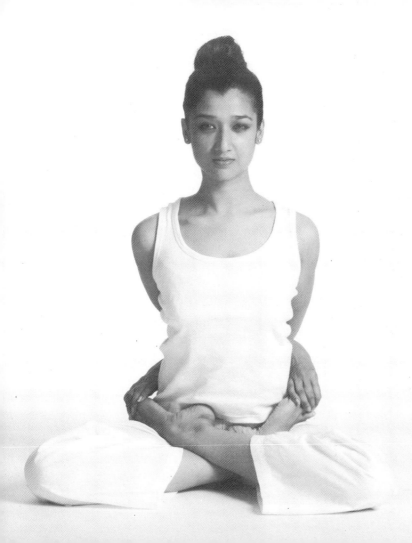

Kukkut Asana (Cock Pose)

The cock pose is an excellent posture to increase memory and concentration; it also brings balance and poise to the body, tones the abdominal organs, the hips and the thighs. It refreshes the brain and releases stress from the body.

- Kneel on the floor. Keep the thighs and feet together, toes pointing inward and resting on the floor.

- Exhale. Place the hips on the ankles, palms by the side of the thighs on the floor, fingertips touching the floor. Focus the gaze at a fixed point at eye level.

- Inhale. Raise the knees up by pressing on the toes. Keeping the ankles together, place the hips on the ankle. Make sure that the ankles and toes do not separate

- Maintain the balance by keeping the fingertips on the floor, abdomen contracted, spine and head held straight.

- Keeping the focus, slowly raise both the arms, bend from the elbows and place the elbows on the thighs. Interlock the fingers and rest the chin on the fingertips.

- Hold the posture for 20 to 30 seconds, breathing normally.

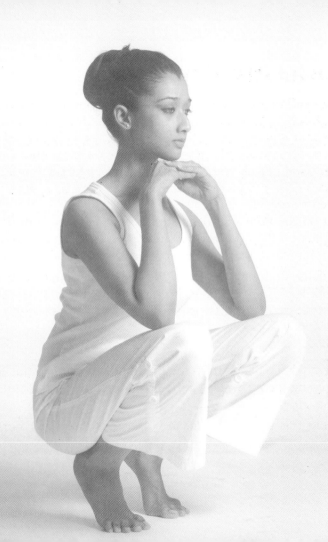

NAUKASANA (HALF-BOAT POSE)

This *asana* will have a wholesome effect on your entire body. It tones the hips, thighs, legs and abdominal muscles. At the same time it will improve your digestion and circulation. It is also very helpful to your entire nervous system and in reducing stress and fatigue. This *asana* tones and strengthens your lower back and abdominal muscles and at the same time massages your internal organs, specifically the reproductive organs.

- Sit on the floor with legs stretched straight in front. Place the palms on the floor by the side of the hips, fingers away from the hips and keeping the spine and head straight.

- Exhale. Reclining the torso slightly back, simultaneously raise both legs from the floor, keeping them stiff and toes pointing out at an angle of 60 to 65 degrees. If you are new to yoga, bend the knees.

- Maintain the balance on the hips and breathe deeply.

- Remove the hands from the floor and stretch the arms forward keeping them parallel to the floor, near the thigh, palms facing one another.

- Hold this posture for 20 to 30 seconds, breathing normally.

- Exhale, lower the legs, relax the hands and release the posture.

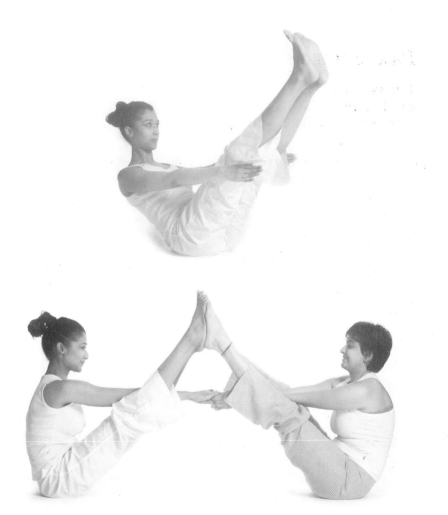

89

PASCIMOTTANASANA (FORWARD BEND)

This *asana* rejuvenates the whole spine, tones the abdominal organs and is very effective to tone the hips, thighs and abdomen.

- Sit on the floor with legs together and stretched out in front of you.
- Place the palms on the floor by the side of your hips and keep your spine erect.
- Inhale. Raise both your hands straight up, stretching your spine upwards.
- Exhale and bend forward, reaching for your toes. Hold your toes with both hands if possible and place your head on your knees. Hold the posture for a few seconds, breathing normally.
- Inhale. Slowly lift yourself back into the starting position.
- Take care to keep the knees and thighs pulled up and the toes flexed inward.

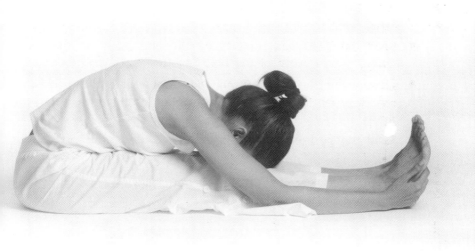

Purvottan Asana (Mountain Pose)

This posture strengthens the wrists and ankles, improves the shoulder joints and makes the spine very supple, increasing the overall strength of the body.

- Sit on the floor with legs together and stretched out in front of you.
- Place the palms on the floor behind the hips, fingers pointing away from the hips and keep your spine and head straight.
- Bend the knees and place the soles and heels on the floor, taking the pressure of the body on the hands and feet.
- Exhale. Lift the body off the floor, straighten the arms and legs, keeping the knees and elbows tight. Stretch the neck and throw the head behind.
- Hold the position for 20 to 30 seconds, breathing normally.
- Exhale. Lower the body down.
- Take care to keep the hip and leg muscles contracted while you hold the posture.

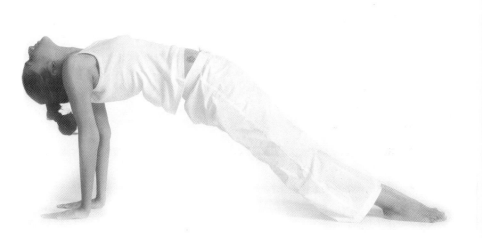

SHASHANKASANA (CHILD POSE)

This is an excellent posture to release premenstrual stress; it helps in releasing stiffness on the upper back and neck muscles. It soothes the mind and creates mental balance.

- Kneel on the floor, keep the thighs and feet together, toes pointing towards each other and resting on the floor. The knees can be kept slightly separated if desired.

- Place the hips on the ankles and sit on the ankles, palms resting on the thighs, spine and neck held straight.

- Close the eyes and breathe deeply for a few seconds.

- Inhale; raise the arms above the head keeping them straight, with shoulder-distance apart.

- Exhale, bend the torso forward from the hips, and place the palms and forehead on the floor, resting the elbows also on the floor.

- Relax the body in this position and hold the posture for 30 to 60 seconds, breathing normally.

- To release the posture, simply inhale and sit up.

- If the hips do not touch the ankles, then place a pillow to fill the gap.

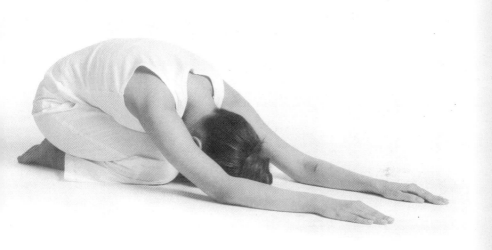

SHAVASANA (DEAD MAN'S POSE)

This *asana* releases all the fatigue and stress from the body and mind. It relaxes the entire nervous system and recharges the body.

- Lie flat on your back on the floor. Keep your hands stretched out alongside your body, with palms facing downwards.

- Position your legs straight out about 2 feet apart, toes relaxed and feet falling out naturally.

- Close your eyes and let your entire body completely relax.

- Focus your mind on your breathing and shut out all external noises.

- Slowly roll your head from side to side, allowing your breathing to stay normal. Stay in this position for as long as you want.

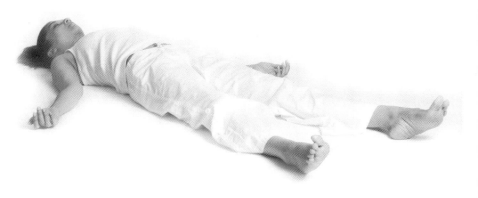

Hasyayog Asana (**Laughing Pose**)

It is fun to end the yoga session with a good laughter, as it releases feel-good chemicals in the body. Called endorphins, these chemicals help in relieving anxiety, stress and tension.

- Stand with feet a hip-distance apart, arms by the side. Close your eyes and focus on the breathing.

- Inhale deeply. Raise the arms over the head and open the eyes, looking at the arms.

- Exhale, laugh out loudly, making exhalation slow and deep.

- Repeat this three to four times.

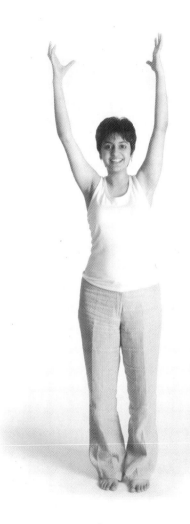

13

Pranayama

Yogis studied in great detail the process of the movement of breath and the effect it has on the body and mind to develop the art of breathing, which they called *pranayama*. With the practice of *asana* and *pranayama*, the mind becomes focused and one can progress quickly towards concentration. It is also used to cleanse, calm and strengthen the nervous system. Yoga breathing exercises teach you to control the *prana* and thus control the mind. Since your breathing reflects your state of mind, by controlling your breathing, you can control your state of mind. The increased intake of *prana* will bring you great vitality and strength. It also steadies your emotions and creates greater clarity of mind. In order to facilitate the flow of *prana*, all *yogic* breathing exercises are performed while sitting down with the spine, neck and head in a straight line. Awareness is always kept on the breath, and focus is on the body where we can feel or hear the breath. Another means for paying attention to the breath is to feel it when it enters and leaves the body at the nostrils.

We must remember that breath is the essence of life and the main support system of the nervous system. The normal tempo of the

breath is slow and on an average we breathe 16 to 18 times per minute, i.e. 25,290 times per day. The more air we exhale the more we can breathe, therefore the habit of conscious breathing should be cultivated. Use the *pranayama* techniques to quieten the disturbed mind, especially when you are nervous during an exam or interview.

In *pranayama* we must clearly understand three technical terms related to it and these are *puraka*, *rechaka* and *kumbhaka*.

- *Puraka* (inhalation) — should be slow, deep and complete with no extra force apllied for taking in air.

- *Rechaka* (exhalation) — should be controlled, slow, deep and uniform. The lungs should be emptied to the maximum extent.

- *Kumbhaka* (retention) — involves stopping of all movements of breath by holding all the respiratory apparatus still.

There is a fixed proportion of time to be maintained regarding the three. It is recommended that *rechaka* (exhalation) should be double the time of *puraka* (inhalation), while the *kumbhaka* (retention) depends upon the progress of each individual practice.

It also becomes important to keep awareness on your breath while you practise any *asana*. Learn to control the way you exhale, and not the way you inhale because energy is renewed by the release of breath, not by strenuously pumping the lungs full of air. Exhaling helps the body to accommodate itself to change. Therefore, change of breath in *asana* can totally change how the posture feels, and it is also one of the best ways of supporting your attention on

the *asana*. Here are a few pointers on this:

- Lengthen the exhalation. Exhale for longer than you inhale as this will induce relaxation and give the mind a soothing effect.

- Lengthen both the inhalation and the exhalation as this will energise the posture.

- Keep the inhalation and exhalation equal as this will stablise attention and focus.

- Gently extend the length of the pauses between each side of the breath to deepen the effect of posture and breath.

Before we embark on learning *pranayama,* it is important to follow a few guidelines:

1. The best position for *pranayama* is sitting on the floor cross-legged, with spine, neck and head in a straight line.

2. All breathing should be done through the nostrils and not through the mouth, unless specified.

3. Your fingers should be in the *chin-mudra,* i.e. your forefinger should be bent towards your thumb, and your finger-tip should touch the tip of the thumb.

5. Like the *asanas*, *pranayama* has to be done on an empty stomach.

6. After the practice of *pranayama,* lie down in *shavasana* for a few minutes.

7. Never try and increase your capacity too fast. Practise *pranayama* for a specific length of time before moving on to more advanced exercises.

Yogic Breathing

This technique helps you to focus on your breathing movements and to relax the mind. It is a very powerful *pranayama* when done under extreme tension. It soothes the nervous system, and when totally focused, it helps you to move forward.

- Sit in a crossed-legged position or lie down in *shavasana*. Relax your whole body.
- Place one hand on your abdomen and the other hand on your rib cage.
- Inhale slowly. Feel your abdomen expand, then the rib cage before your upper chest. This is one complete inhalation.
- Now exhale. The air will leave your lower neck and upper chest, moving your chest downward. Next, allow your diaphragm to push upward towards your chest.
- Empty your lungs completely by drawing your abdominal wall as close to your spine as possible.
- Try and do five to 10 rounds of this breathing exercise, and increase gradually to 20 rounds.
- Your breathing should be done in one continuous movement.

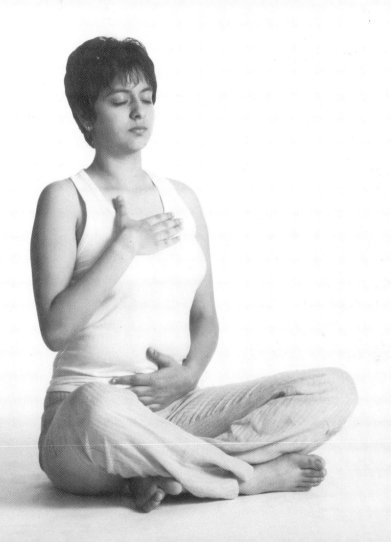

BHASTRIKA PRANAYAMA

The regular practice of this exercise burns up toxins and removes diseases; there is an increase in the exchange of oxygen and carbon dioxide into and out of the bloodstream, thus increasing the metabolic rate and improving the digestion. Youngsters suffering from asthma and lung disorders must practice this on a regular basis.

- Sit in a comfortable cross-legged position or in a meditative posture. Relax your entire body and keep your eyes closed. Allow your breath to become calm and rhythmic.

- Bend your right arm from the elbow. Fold your middle and index fingers inward to your palms. Bring your ring finger and the little finger towards your thumb.

- Place your right thumb on the right side of your nose and your ring and little fingers on the left side of your nose. By pressing your thumb, block your right nostril.

- Inhale and exhale fast and vigorously only through the left nostril at least 10 to 20 times.

- Close the left nostril. Open the right nostril and repeat the same inhalation and exhalation 10 to 20 times.

- Release the fingers from the nostrils.

- Take a few deep breaths and repeat the same cycles on both the sides three to four times.

- After completing the rounds, lie down in *shavasana*.

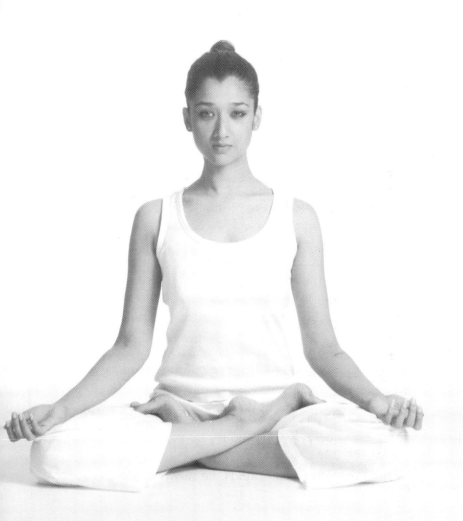

NADI SHODHANA (ALTERNATE NOSTRIL BREATHING)

In this *pranayama*, your blood receives a larger supply of oxygen than in normal breathing; your mind feels very relaxed and calm. It not only soothes your entire nervous system but also increases vitality, clarity and lowers stress levels.

- Sit in a comfortable cross-legged position on your shins with hips touching the ankles (*vajarasana*). Relax your entire body and keep your eyes closed. Allow your breath to become calm and rhythmic.

- Bend your right arm from the elbow. Fold your middle and index fingers inward to your palms. Bring your ring finger and little finger towards your thumb.

- Place your right thumb on the right side of your nose and your ring and little fingers on the left side of your nose. By pressing your thumb, block your right nostril.

- Inhale slowly and deeply through your left nostril to the count of four. After a full inhalation, block your left nostril with your ring and little fingers and retain your breath to the count of 16.

- Exhale, releasing the pressure from your right nostril and releasing the air slowly, deeply and steadily to the count of eight.

- Next, blocking your left nostril, inhale deeply from the right nostril to the count of four. After a full inhalation, retain your

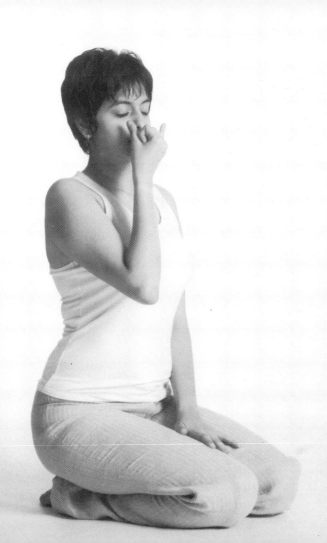

breath for 16 counts. Block your right nostril and exhale slowly, deeply and steadily for eight counts, simultaneously releasing the pressure slowly from the left nostril.

- This completes one round of the *pranayama*. Try to do four to eight rounds.
- Lie down in *shavasana* and relax.
- Do not force your breath and never breathe through your mouth. At any slight discomfort, reduce the duration of inhalation, retention and exhalation. Practise this *pranayama* with full awareness and during retention, focus your eyes on the point between the eyebrows (*ajna chakra*).

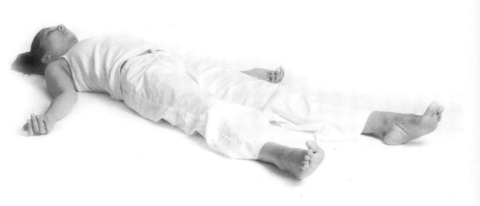

Kapalabhati Pranayama

In Sanskrit, *kapala* means 'skull' and *bhati* means 'shining'. It means that if you practise this *pranayama*, your face will glow with good health. This *pranayama* purifies your entire system and releases toxins from your body. It removes depression, dullness and lethargy.

- Sit in a comfortable crossed-legged position, keeping your spine straight and hands resting on your knees in the *chin-mudra*. Relax your body and breathe deeply.

- Inhale deeply through the nostrils, expanding your abdomen.

- Exhale with a forceful contraction of your abdominal muscles, expelling the air out of the lungs.

- Inhale again, but passively, allowing your abdominal muscles to expand and inflate your lungs with air, without any force. This is going to be a pumping effect of passive inhalation and expulsion of breath in a continuous manner.

- Do eight to 10 breath expulsions. Then inhale and exhale deeply for two rounds followed by retaining of breath for 20 to 30 seconds

- Practise three rounds of *kapalbhati*.

- Take care, not to strain while performing this *pranayama*. Your facial muscles should be relaxed. If you feel any pain or dizziness, stop the practice for some time.

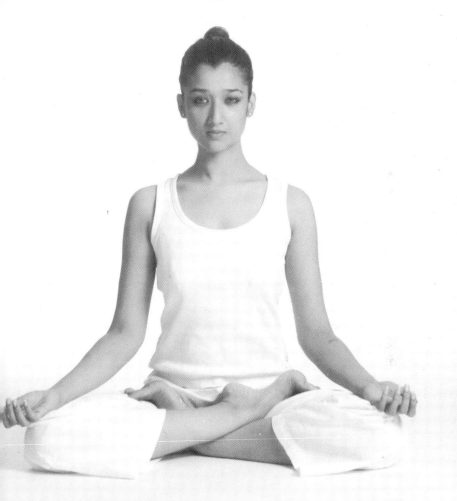

113

14

Meditation

Most youngsters are under the illusion that meditation is a boring task and is not at all different from 'dozing off', but they must understand that in this competitive and changing world, we all need to hold on to a technique that will calm us and connect us to ourselves and keep us stable. Meditation is the process of stilling the mind against outside distractions and discover peace and wisdom within yourself. Regular meditation will give you a greater sense of who you are and what you want. It helps you to focus your mind and calmly face external influences.

As a child, you are taught to examine the outer world and nobody teaches you to look within. The regular practice of meditation will lead you to a state of inner joy and balance. Meditation will give a peaceful mind, make you fearless and calm, and at the same time help you understand the working of the mind. A growing girl's body is going to change; there will be lots of hormonal changes taking place inside, which will influence the external appearance. Regular practice of meditation will help you understand this changing phase of life.

Everyone seeks peace of mind, though the routes taken may differ. Some use soft soothing music to erase the tensions of the day, some read quietly and still others find their peace in prayer. The purpose of all these activities is to focus the attention on any one point of concentration and still the mind, shutting away all other thoughts till the internal incessant chattering stops. As the mind calms down, and worries are forgotten, there begins a growing feeling of contentment. With the continued practice of meditation, you can discover a greater sense of purpose and strength of will and your thinking becomes clearer and more concentrated, affecting all that you do.

Meditation gives you a clear understanding of yourself and helps you recognise your strengths and weaknesses. The strength of character that the practice of meditation gives you will help you think and speak for yourself.

Meditation is not a difficult task that you must force yourself to do; anything that you do with your full awareness is meditation. So it becomes important that you set a routine for your meditative practice. Just as you eat or go out with your friends at certain times throughout the day, as the time approaches you look forward to it, in the same way develop the habit of meditating at the same time each day.

Find yourself a quiet place where you will not be disturbed.

The next step to learn is to be still, and this stillness begins with physical stillness, and follow the *asana* or meditative posture that suits you. Practice the same posture till the body gets use to it.

Once the body is still and comfortable, the next step is to bring

your awareness to your breath and continue to observe the breath, but don't try to control the breath.

Then give full attention to whatever object or sound you choose. Simply remain aware of this instead of reacting to the thoughts. This is also applicable to all the work that you do, studying or playing, giving full attention to whatever you do. If you love the things that you are doing, if you love the way you are, then nothing distracts you when you are in a meditative state. When thoughts distract you, it simply shows that you are not really interested in the work that you are doing.

Have patience and practice regularly, remembering that every action has a reaction and it is not possible that you will meditate and never reap the benefits. Keep your mind focused and never give up.

The signs that will help you realise that meditation is working on your system are that you will feel calmness of the mind, your output in your work will increase and you will live your life with full awareness.

CHAKRA MEDITATION

The practice of this meditation will purify the basic elements that the body is made of and energise the *chakras* and release toxins from the body.

- Sit in a comfortable meditative position, close your eyes and focus on the breath while regularising your breathing.

- Now focus on the *muladhara chakra,* the abode of element, Earth.

- Visualise a yellow square surrounded by four petals.

- Create a root lock by squeezing the anus muscles by pulling them upwards. Allow the mind to move into the region, while mentally chanting '*Aum*' 16 times.

- Now focus on the *svadishthana chakra,* the abode of water element just above the genitals.

- Visualise an ocean-blue circle with a white crescent moon in the centre surrounded by six petals.

- Mentally chant '*Aum*' 16 times.

- Move upward to the *manipura chakra*; the navel is the centre or abode of fire.

- Visualise a triangle pointing upward with 10 petals enclosed around the triangle.

- Mentally chant '*Aum*' 16 times.

- Move upward till you reach the heart centre or the *anahata chakra*, the abode of air.
- Visualise two smoky grey triangles, one superimposed on the other and encircled by a 12-petalled lotus.
- In the centre is the *jiva*, the individual soul, in the form of a flame, chanting *'Aum'* 16 times.
- Move upward, until you reach the centre of the throat or the abode of *ether*, space. Here the sky is a blue circle and is surrounded by 16 petals, chanting *'Aum'* 16 times.
- Moving upwards, reach the *ajna chakra*, the centre between the eyebrows and the abode of wind.
- Visualise a yellow triangle surrounded by a circle and a bright white flame enclosed in the triangle; outside the circle are two petals.
- Mentally chant *'Hum'* 16 times.
- Still moving upwards reach the *sahasrara chakra*. A 1,000-petalled crown is the centre of the abode of the spiritual master—pure consciousness.
- Experience countless rays of white light. Visualise a 1,000-petalled lotus with a pinkish aura.
- Mentally chant *'Humsa'* 16 times.
- Feel the energy all around the *chakra* and meditate.

VIBRATION MEDITATION

This technique uses a sound or word as its focal point. Vibrational meditation appeals to those who find that making noise is a path to inner peace, as release of sound and noise help to release stress.

- Sit in a meditative posture or lie down in *shavasana*.

- Keep the body loose and comfortable with the arms on the knees or by the side.

- Begin by taking a few cleansing breaths and relax the body.

- Pick a word; the word that you select need not be a spiritual one or a sentence. It just has to feel good when you keep repeating words like "love", "serenity" or "every day in every way I will do the best for myself."

- Repeat the word, chant the word, focus on nothing but saying the word over and over again. Let the sound of the word vibrate through your body.

- Let the word resonate up from your abdomen and let it go to your hands and feet; let your muscles move as you chant the word. Some have the tendency to clench their muscles when they're tense. It's important that you roll the sound through your body so that you can clear out the tightness in your muscles.

- Keep doing this till a meditative state of relaxation sets in, which is a natural high on its on.

MOVEMENT MEDITATION

This meditation involves breathing and gentle flowing movements to create a meditative state. It appeals especially to all teenagers as they achieve a meditative state of mind by moving their bodies. It allows a person to take in energy from the earth and release all the stress from the body, thus calming the mind.

- Stand with the feet a hip-distance apart, arms by the side and shoulders relaxed. Switch on music that you really like.

- Take a few deep breaths and relax the body.

- Concentrate by visualising your feet connected to the earth, drawing energy from the earth.

- Focus your awareness on the body and gently move the body, swaying it with the sound of the music. Dance if you like.

- Focus your attention on the movement and on the vibration of the sound.

- Allow yourself to get lost in the sense of movement and the beauty of your body as it moves. Feel the areas of your body that are tight. Let the movement loosen them up.

MEMORY SHARPENING MEDITATION

As the name suggests, this meditation sharpens the memory and within a reasonable time of practice, you will have more confidence in your memory.

- Sit in a meditative posture. Close your eyes and relax the body by breathing deeply.

- Fix the gaze at the inner surface of the eye with calmness. Gaze as if you are looking into a soft, dark space.

- Now, on the surface of that space, begin to trace the numbers with your eyes. Write each number clearly with your eyeballs, as if you are writing with a pen on the inside of the eyelids. For several days or weeks write the numbers from one to 50 or 100.

- As you write, relax the body and do not strain mentally.

- When you have become comfortable with the process, complete the number from one to a letter you choose near the beginning of the number, e.g. 25.

- When you reach the chosen number, simply start to write backwards to number one without any strain.

- Gradually train the mind to ascend and descend through the numbers, writing one to 100, forward and backward with your eyes.

15

Relaxation

Relaxation is a state of the mind and body where the entire nervous system is completely at rest. Many problems that you experience are caused by stress, anxiety and tension, which eventually manifest as physical and mental illness. The relaxation techniques used in yoga relax the body and the mind. As the vital energy is brought into balance, vitality is restored and a complete fresh and optimistic outlook on life is experienced.

The relaxation techniques used in yoga are extremely simple and yet the benefits are felt immediately after the first session. You need not try to relax or believe that the practice will work; all you have to do is simply 'let go' and follow all the instructions till all the stress and tension in life disappears. You must also understand that when you relax, tension and anxiety disappear, the will power becomes stronger, and you get the strength of mind to tackle other aspects that may be troubling you.

The beautiful thing about relaxation techniques taught in yoga is that you are conscious throughout the experience and can control it and take part in the relaxation.

Yoga Nidra (Auto Suggestion)

- Lie flat on your back with your arms stretched out and relaxed by your sides, palms facing upward. Close your eyes.

- Breathe deeply, making each exhalation longer then the inhalation.

- Contract the muscles of the body, including facial muscles, for a few seconds and then consciously relax them.

- Scan the entire body muscles from the feet to the face to check that they are relaxed.

- Focus on the bodily sensation of no tension and let the breath flow freely.

- Stay relaxed in that position for as long as possible.

- Stretch gently and lazily, and get up slowly.

- Allow this relaxation to end on its own, as the body knows best when it is relaxed sufficiently.

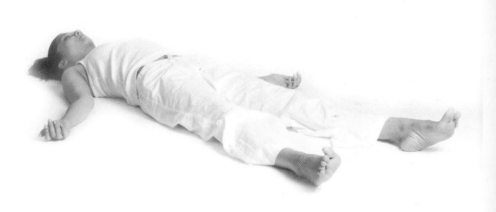

Nutrition and Weight Loss

Young girls are under the impression that eating low fat food and low calorie drinks helps in absorption of fat, and that is why these are in great demand among youngsters because they all are afraid of gaining weight.

Eating disorders are extremely common in teenagers as it is their attempt to control and manage the issue of weight and food. The most common type of eating disorders among young girls are described below.

ANOREXIA NERVOSA

Anorexia nervosa is characterised by an intense fear of gaining weight, denial of the severity of current low body weight and is a significant disturbance in the way a person perceives her own body. These characteristics contribute to marked weight loss and a refusal to maintain an appropriate weight for age and height. Anorexia plays havoc with the metabolism, because the body is made to starve for long. It cannot go back to normal weight overnight or in weeks; it all depends on the length and severity of the bout of anorexia.

BULIMIA NERVOSA

This eating disorder is characterised by repeated cycles of binge eating and purging; a binge is classified as a large amount of food consumed in a very short period of time. The binge then is accompanied by feelings of guilt and disgust and then the person binges more.

BINGE EATING DISORDERS

This eating disorder is commonly known as compulsive overeating and is characterised by periods of binge eating or continuous eating. Although the binges do not result in purging as in bulimia nervosa, they produce intense feelings of guilt and self-hatred.

All young girls are at a potential risk, so it is essential that they recognise this and take steps to overcome these eating disorders. It is here that yoga really works wonders for all youngsters as it inculcates discipline and direction that teenagers need to keep the body healthy and the mind focused.

The first step towards this is to accept the way you are and learn to take care of the body. At the same time accept that any unhappiness that you experience has more to do with what is going on in the head rather than what the scales or mirror show.

All youngsters are unhappy with their weight or the shape of their body, but most do not know how to change it and many accept to remain the way they are. You would want to look like someone you have seen in a magazine and the goal may not be healthy or realistic for you as it leads to unhappiness and disappointment.

Remember there is no magical diet or pill that will make you look thin. Let us take a look at a few suggestions that will be helpful to you.

Make Weight Loss A Family Affair

Ask your Mom or Dad to support your decision and help you make dietary or lifestyle changes that might benefit the whole family. Teens, who have the support of their families tend to have better results with their weight loss programme because the whole family works together in a friendly and helpful manner, making weight loss a lot of fun.

Watch Your Drinks

It is amazing how many extra calories teens consume by drinking aerated drinks. Drink lots of water and other sugar-free drinks to quench your thirst and stay away from sugary drinks. Get in the habit of eating fresh fruit and vegetable juices; switch from whole to non-fat milk; add buttermilk to the diet.

Get Moving

You will soon realise that you need not give up calories as much as you have to get up and move your butt, walk to school, walk up the stairs rather then taking the elevator and most importantly, turn to an exercise routine, that will help you achieve your goal.

Start Small

Always remember that small changes are a lot easier to stick with than the drastic ones. Try reducing the size of the portions you eat and start introducing healthier foods and exercise in your life.

Stop Eating When You Are Full

It is seen that teens eat when they are bored, lonely and stressed or keep eating long after they are full, out of force of habit. Start to eat with awareness and pay attention when you eat and stop when you are full. Avoid eating when you feel upset or bored; instead, find something else to do that will take the mind off boredom, like go for your yoga class or simply take a walk.

Eat Less More Often

Eat small snacks throughout the day rather then eating three fixed meals. Divide the three meals and if you do feel like eating, then switch to healthy snacks like a fruit or a low calorie snack.

Make Healthy Food Choices

Ditch the junk food and dig out the fruits and vegetables. Replace white bread with whole bread, banish sugar from your diet, add a few cups of low fat milk and make sure that you don't miss breakfast as it is the most important meal of the day. Taking cereal and milk and a piece of fruit is better than taking no breakfast at all.

Remember, we are not meant to eat stale and packed foods; we all need a variety of foods to stay healthy. So, stay away from fat diets and pills as they do not supply the body with proper nutrients, and are harmful for the body. There is no proof that they will help you lose weight.

Don't Banish Your Favourite Foods

Don't tell yourself that you will not eat your favourite chocolates, ice-creams or packets of chips, as making these foods forbidden is sure to make you want to eat them more. The best way to deal with this is to have the food you desire and then later balance it out by burning the calories through a daily exercise routine.

Forgive Yourself

Everyone who is trying to lose weight finds it very challenging to curb the desire to eat, so when you do slip, the best thing to do is to get right back on track and never look back.

Make A Journal

Keep a diary of what you eat and then review the diary daily. Identify the emotions that you were experiencing when you overate or keep a watch to check if you have unhealthy eating habits.

17

Yoga, Part of the Lifestyle

Before embarking upon the practice of yoga, it is important for you to know that yoga will change your lifestyle in no other way except for the better. You are absolutely free to carry on with any kind of lifestyle you choose for yourself. Whether you get up early in the morning or late, whether you eat lunch at 12 noon or at 1.00 p.m. or 2.30 p.m., whether you picnic every Sunday or dance every Saturday, you are vegetarian or non-vegetarian—it just does not matter. You can practise yoga comfortably whatever be your life's habits. All that is required is a little time, a small space, a commitment, and most importantly, a firm resolution to make it a part of your lifestyle.

Yoga will help you towards leading a much more fulfilling life physically, mentally and socially. The practice of yoga will help teenagers to stay healthy and build flexibility and strength. It instils a rejuvenated sense of confidence, heighters self-esteem and cultivates an optimistic approach to the problems of adolescence. It will teach you to relate to stress, face strain and learn to reduce it effectively. Yoga will give you success in all spheres of life and you will excel in your career.